This Little Tiger book belongs to:

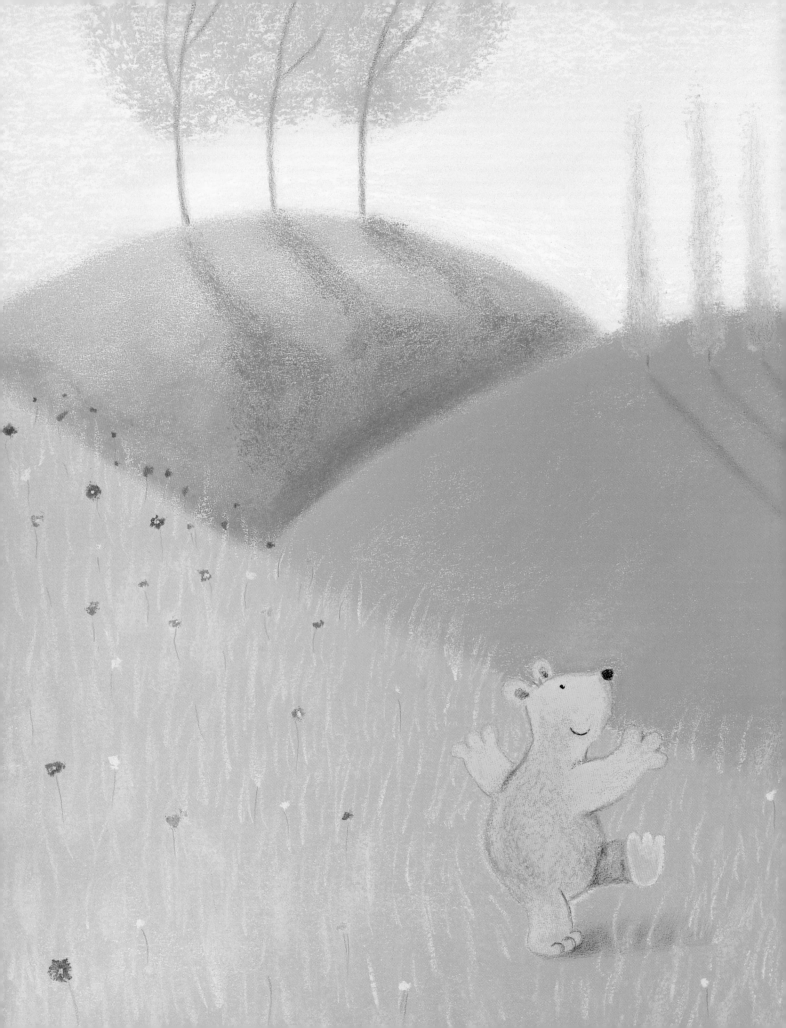

For Joey
– A R

To every child in this world who, because of war,
is deprived of a peaceful and playful childhood
– D K

LITTLE TIGER PRESS
1 The Coda Centre, 189 Munster Road
London SW6 6AW
www.littletiger.co.uk

First published in Great Britain 2005
This edition published 2014
by Little Tiger Press, London

What Bear Likes Best!

Alison Ritchie

Dubravka Kolanovic

LITTLE TIGER PRESS

Bear was sunning himself
on a grassy hilltop.
He loved days like this—
nothing in particular to do and
nowhere in particular to go.

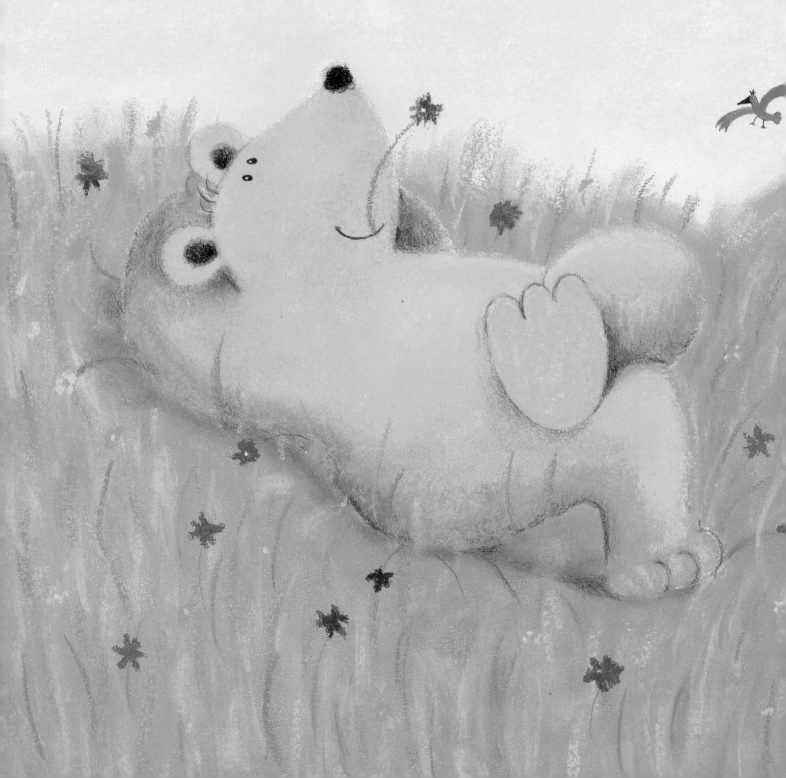

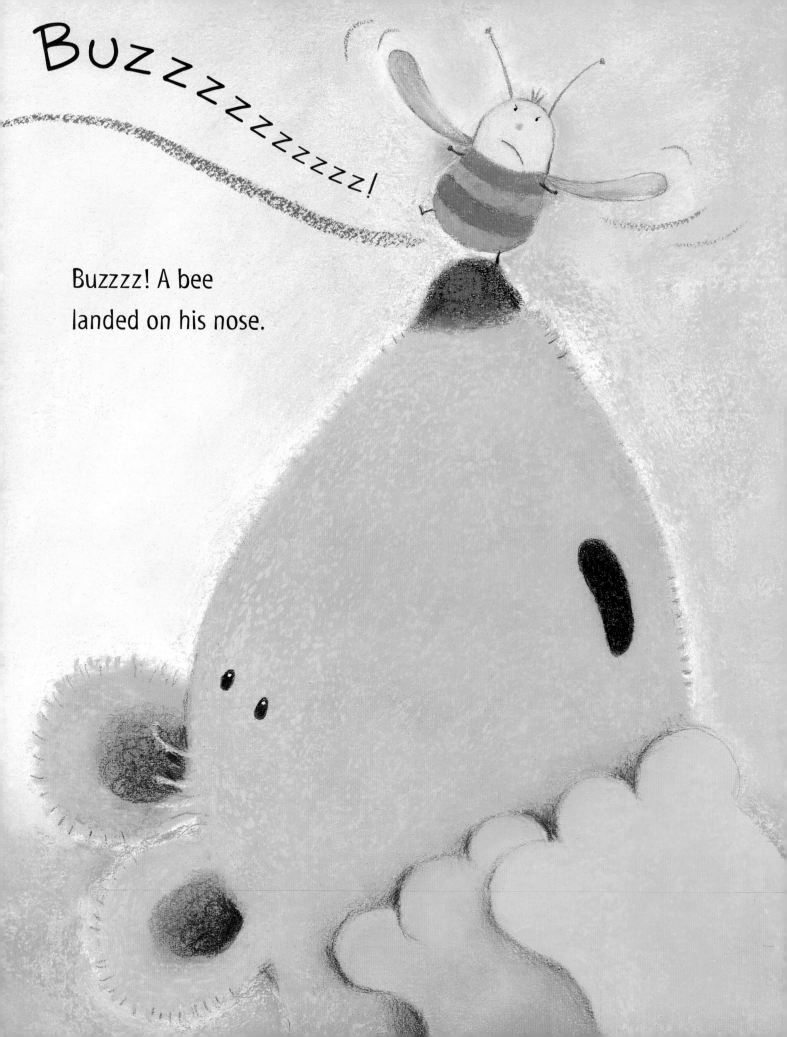

Buzzzzzzzzzzz!

Buzzzz! A bee
landed on his nose.

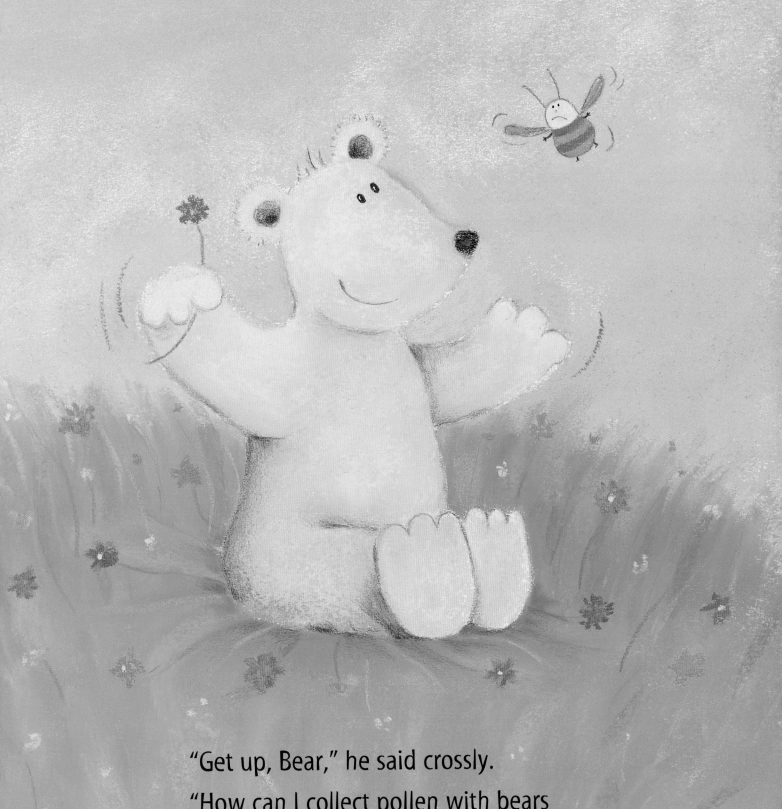

"Get up, Bear," he said crossly.
"How can I collect pollen with bears
squashing my flowers?"
"Sorry, Bee," said Bear, laughing.

Bear curled himself up
and roly-polied down the hill.
Roly-polying was one of the
things he liked to do best.

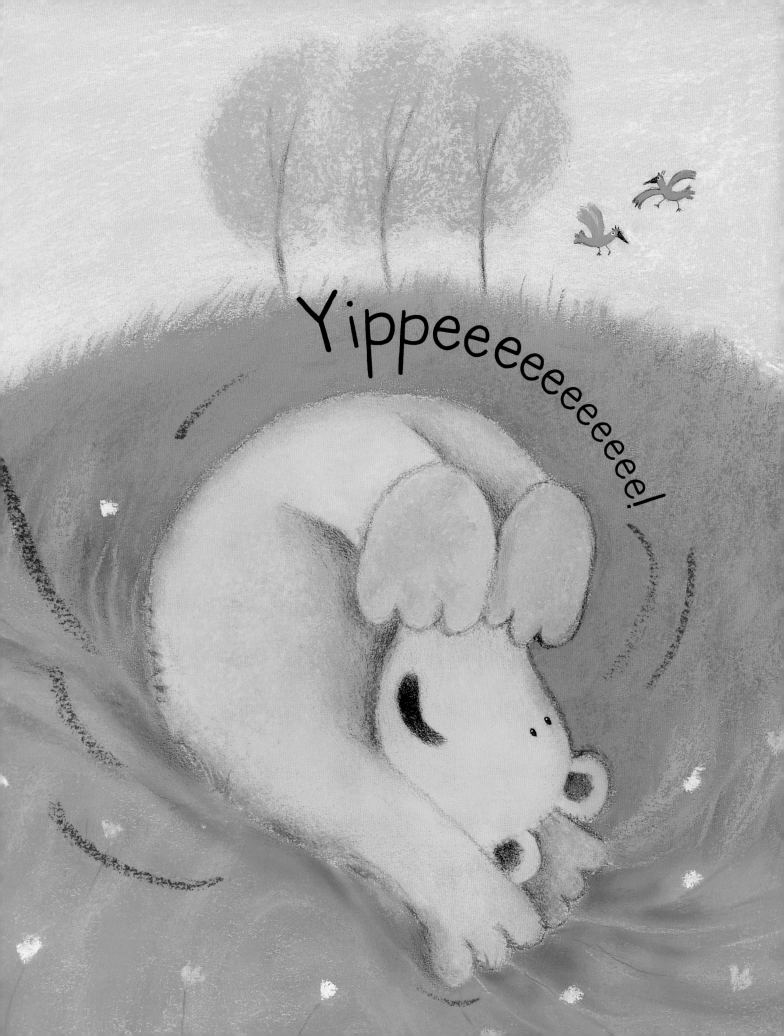

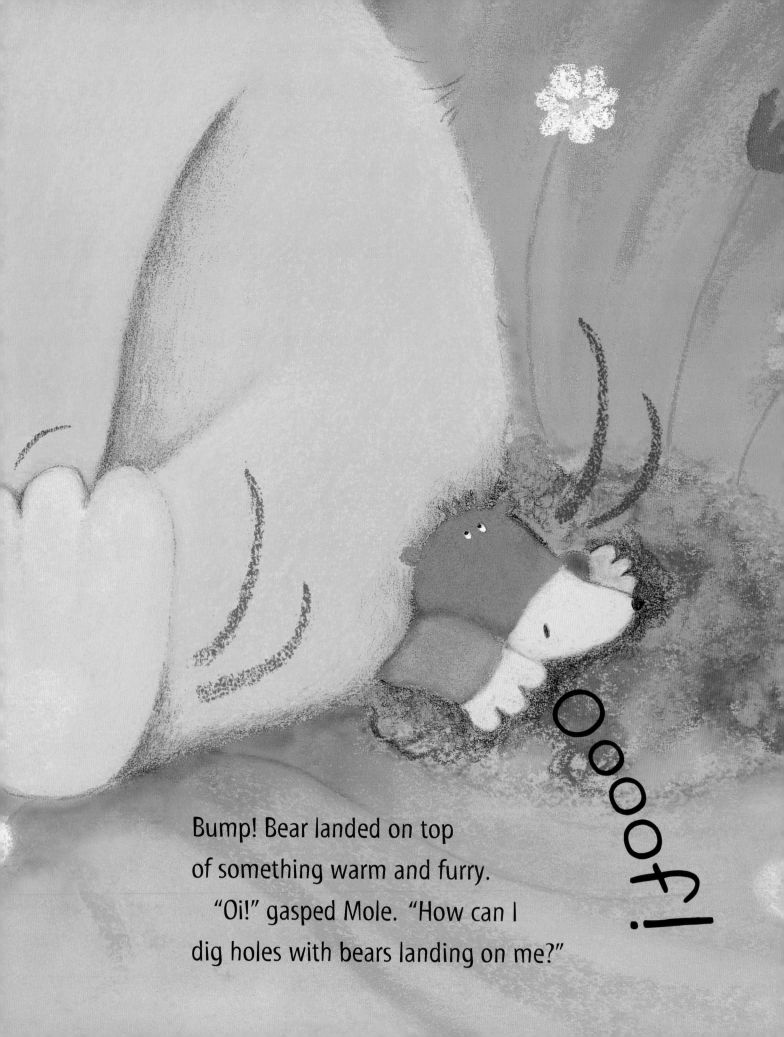

Oooof!

Bump! Bear landed on top
of something warm and furry.
"Oi!" gasped Mole. "How can I
dig holes with bears landing on me?"

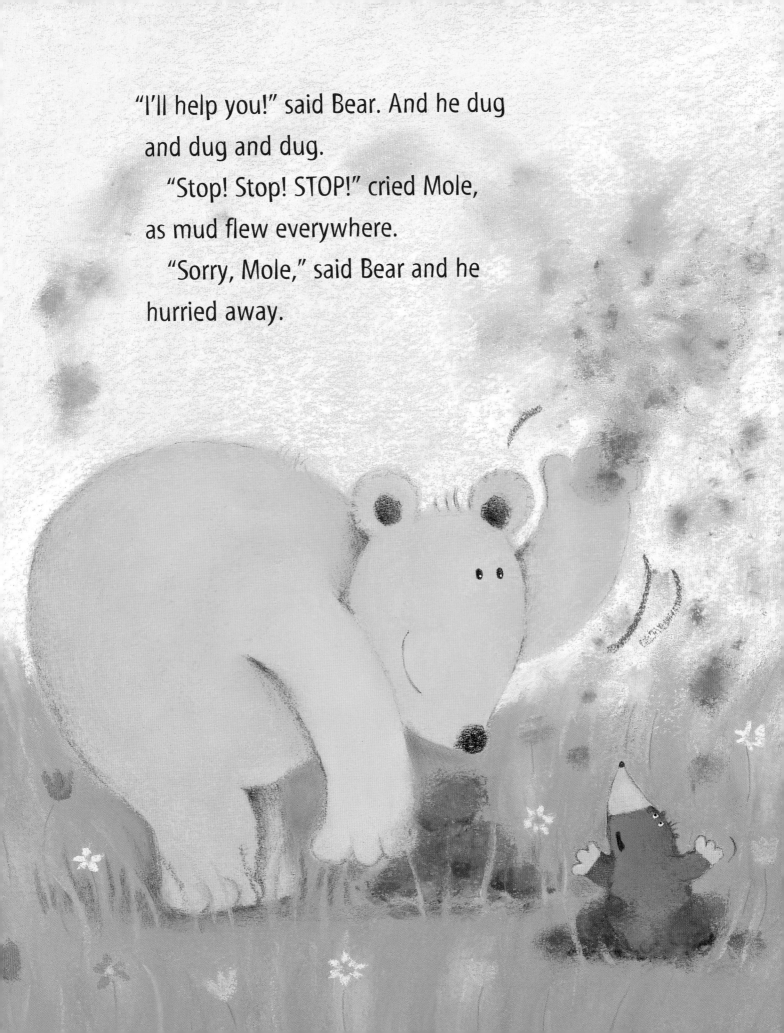

"I'll help you!" said Bear. And he dug
and dug and dug.
 "Stop! Stop! STOP!" cried Mole,
as mud flew everywhere.
 "Sorry, Mole," said Bear and he
hurried away.

Bear ran down to the river
and splashed in the water.
Splashing was one of the
things he liked to do best.

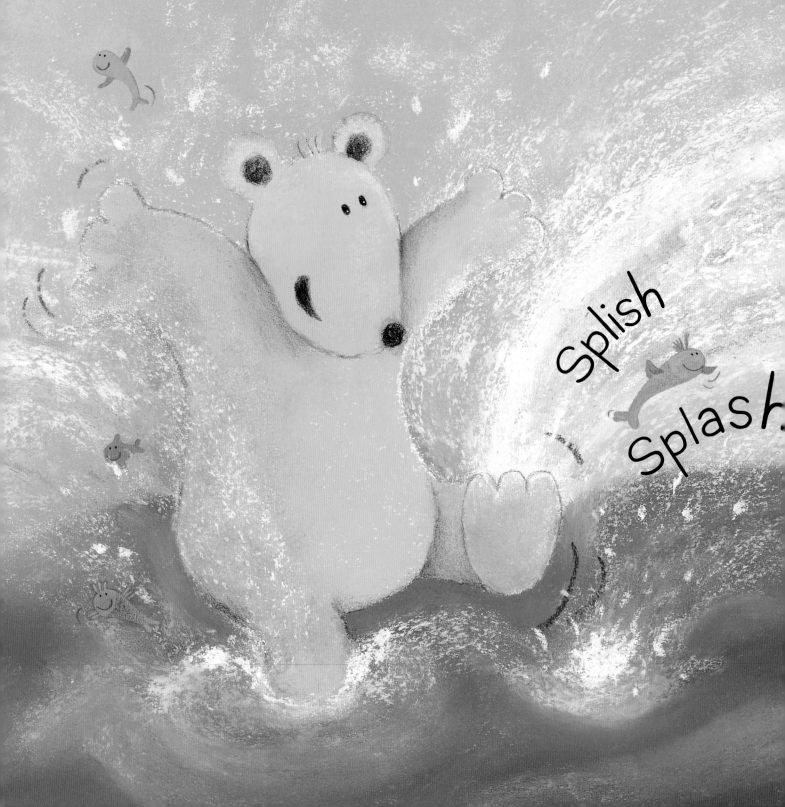

Splish

Splash

"Hey!" grumbled Heron. "How can I catch
fish with bears chasing them away?"
"Sorry, Heron," said Bear and he
bounced off to play somewhere else.

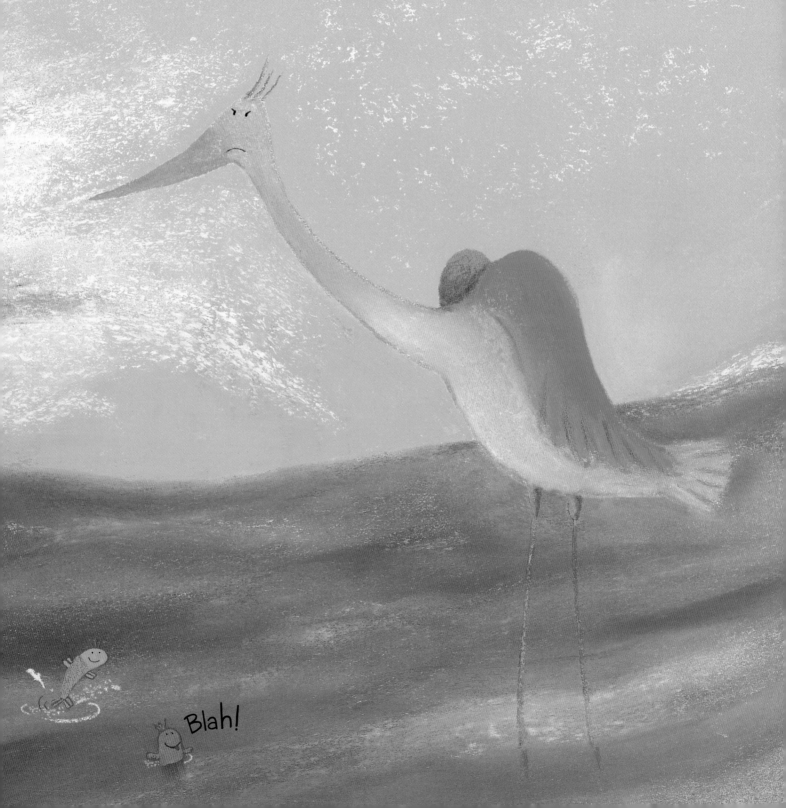

Blah!

Bear hopped across the stepping stones, leaped onto the riverbank, and ran into the woods. It was time for a back scratch. Scratching his back was one of the things he liked to do best.

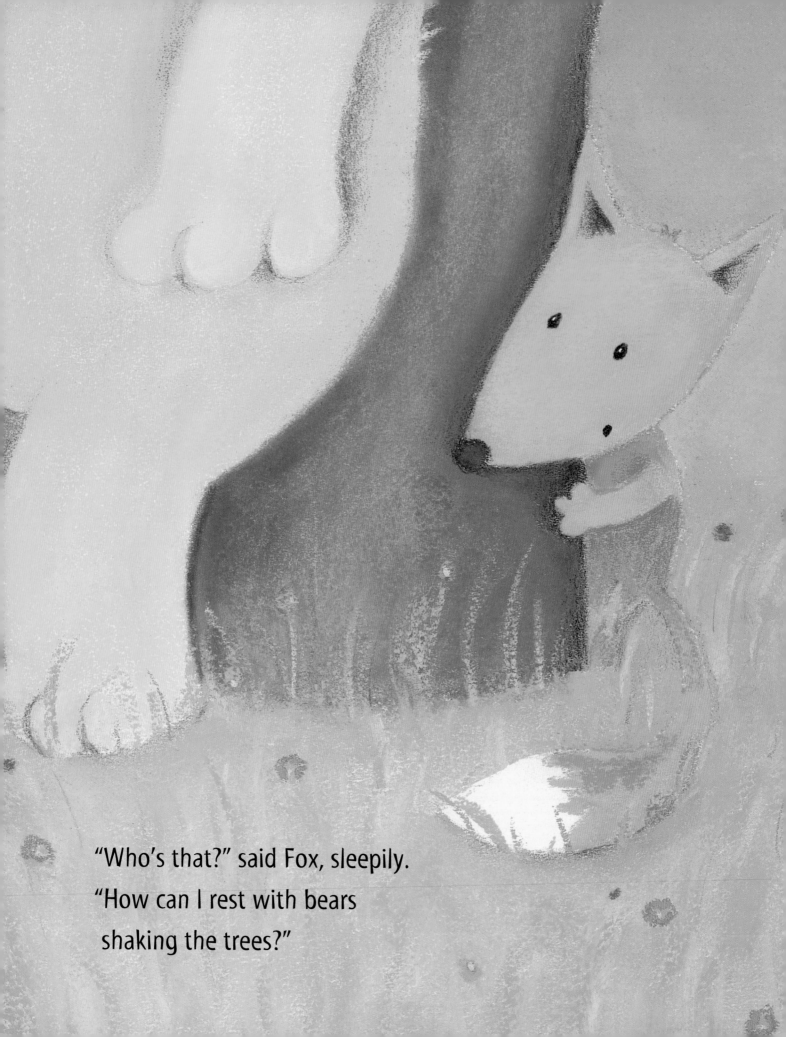

"Who's that?" said Fox, sleepily.
"How can I rest with bears
shaking the trees?"

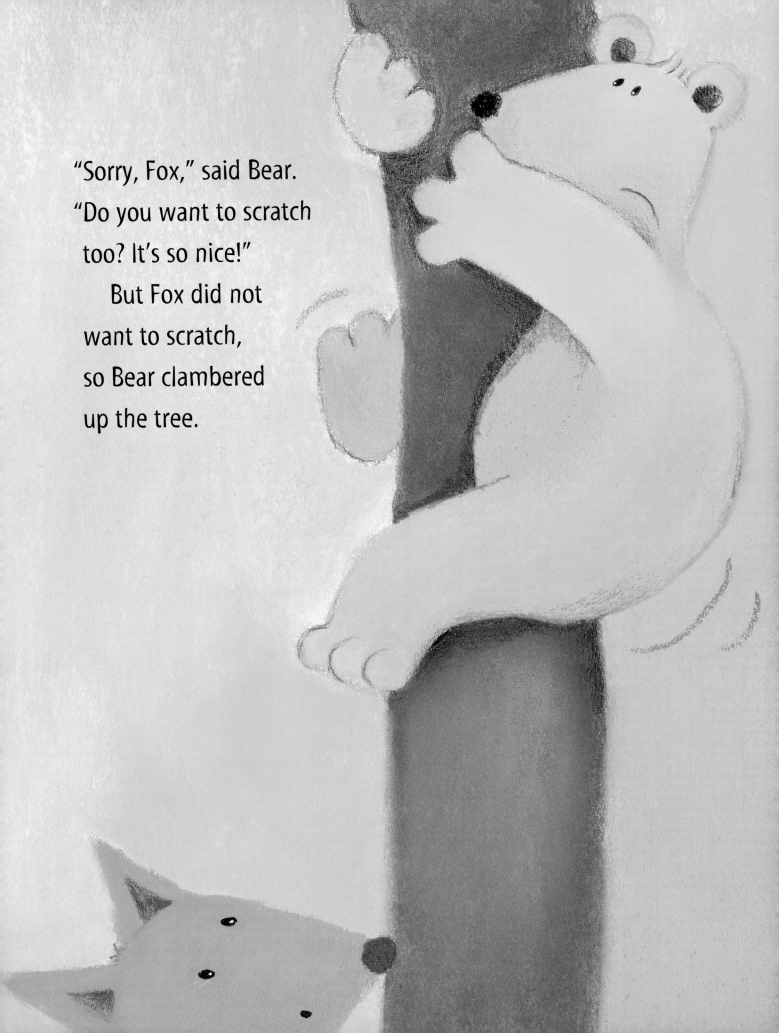

"Sorry, Fox," said Bear.
"Do you want to scratch
too? It's so nice!"
But Fox did not
want to scratch,
so Bear clambered
up the tree.

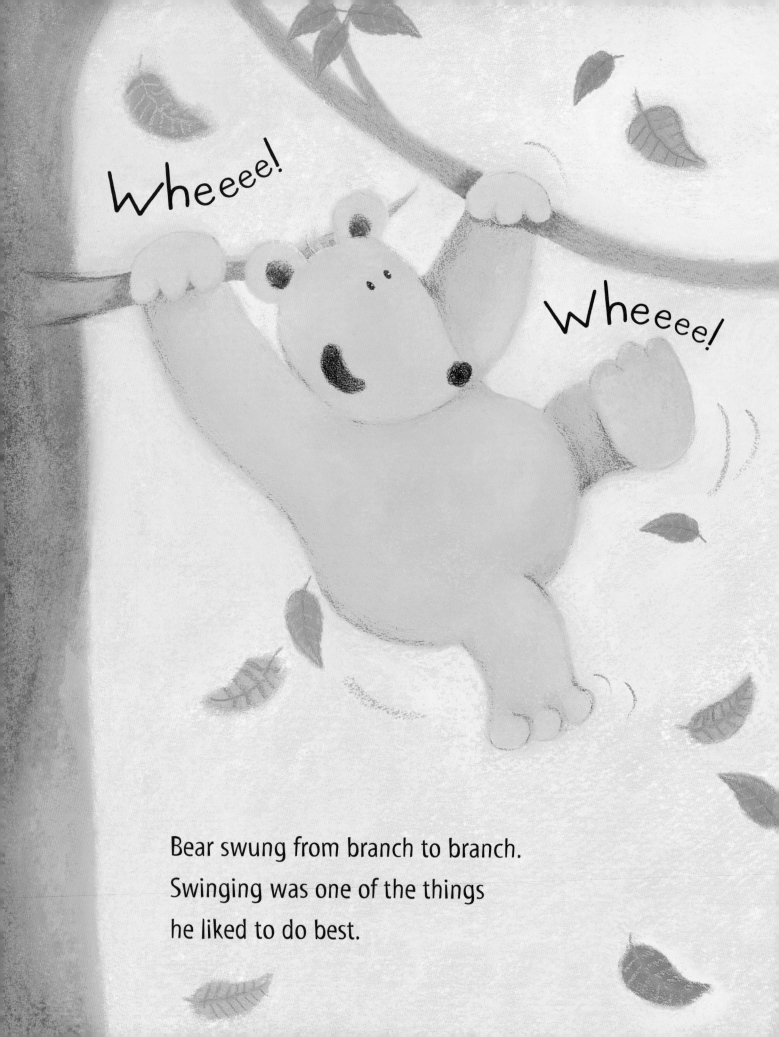

Wheeee!

Wheeee!

Bear swung from branch to branch.
Swinging was one of the things
he liked to do best.

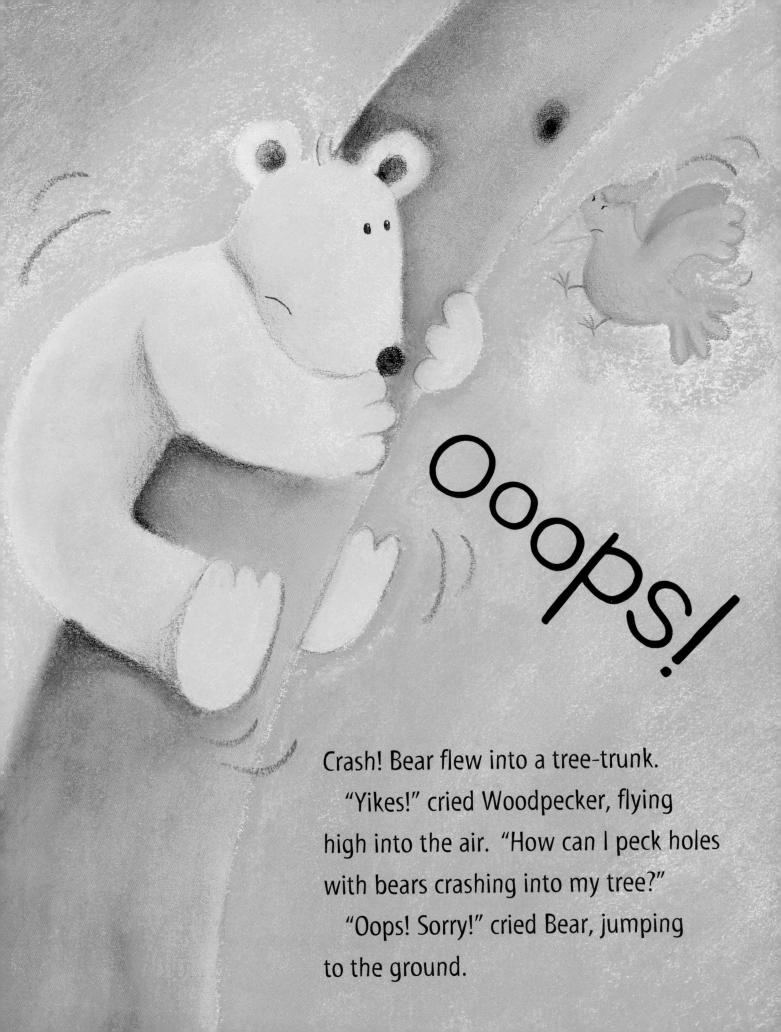

Ooops!

Crash! Bear flew into a tree-trunk.
"Yikes!" cried Woodpecker, flying
high into the air. "How can I peck holes
with bears crashing into my tree?"
"Oops! Sorry!" cried Bear, jumping
to the ground.

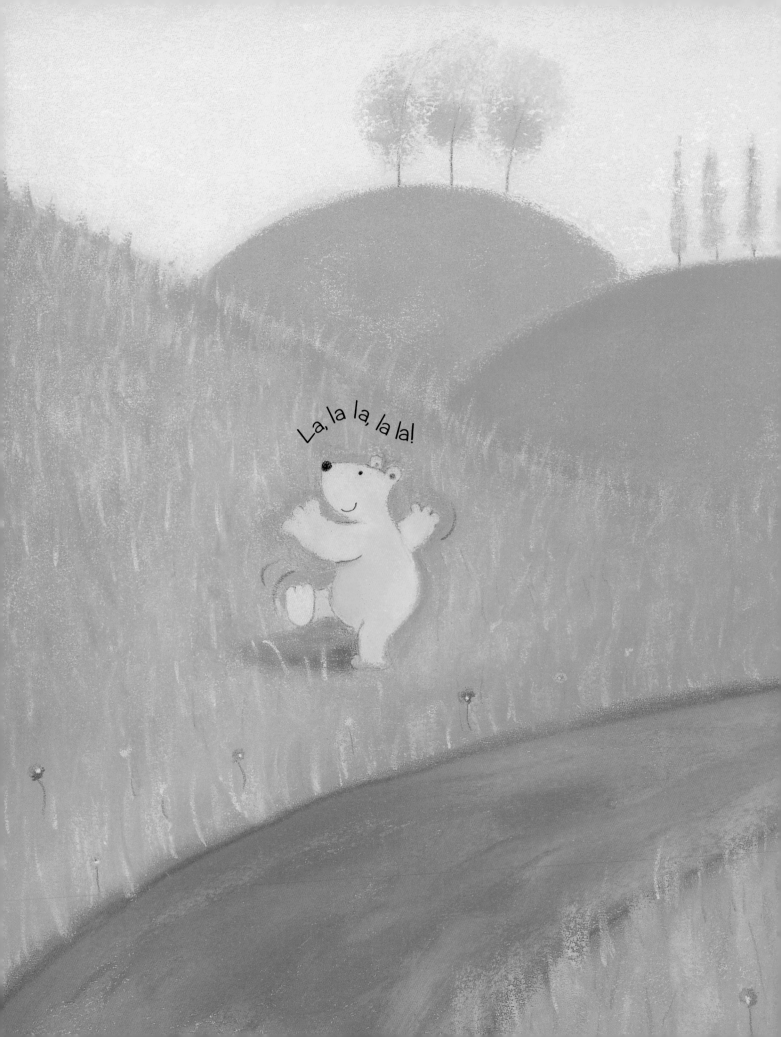

"Everyone's too busy to play,"
Bear thought sadly. "Oh, well!"
He skipped through the woods,
along the riverbank, across the field
and back to his special hilltop.

Bear lay sunning himself on the hilltop.

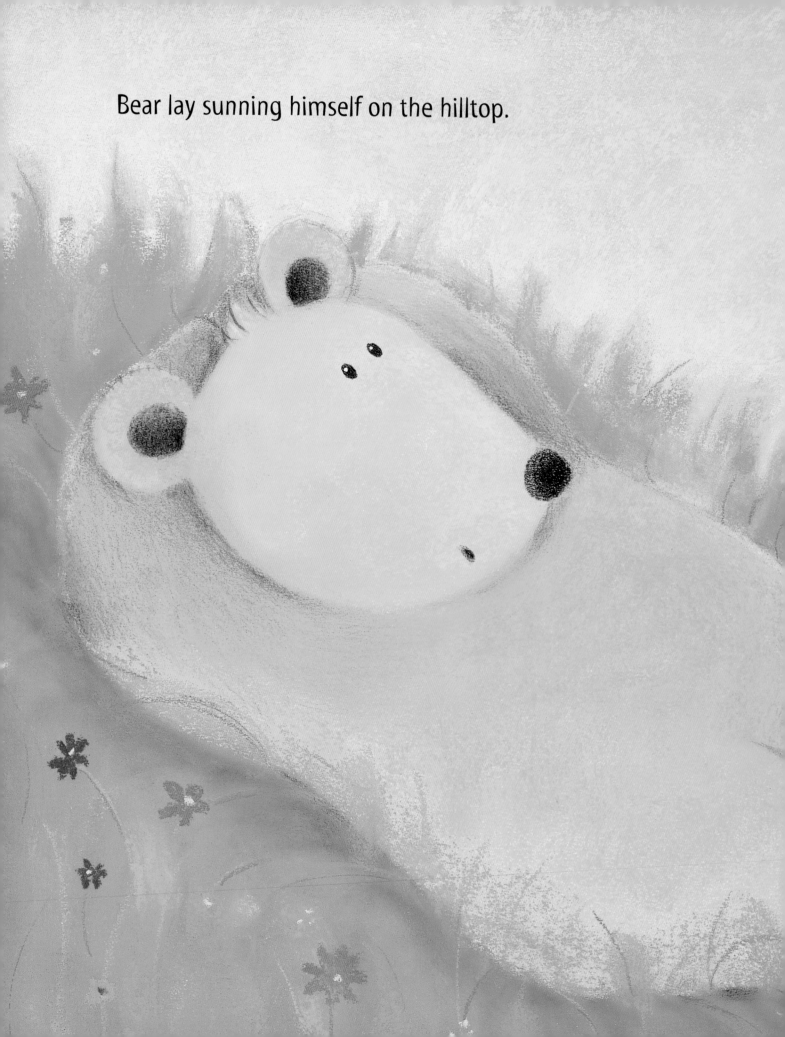

Suddenly he heard a loud BUZZZZZZZ!
"Oh, no! I'm in trouble again," he thought.

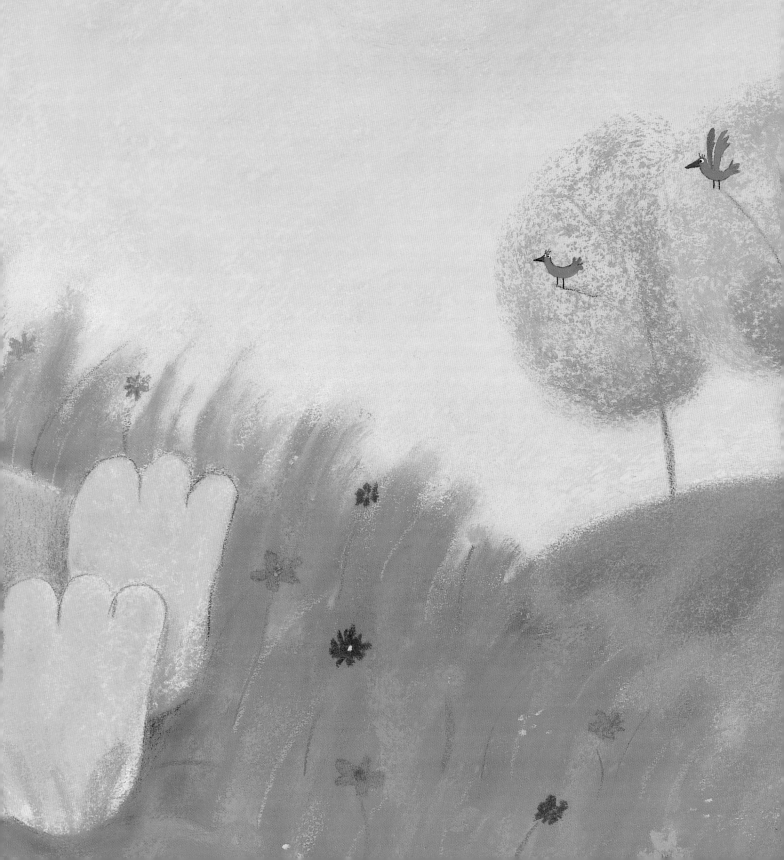

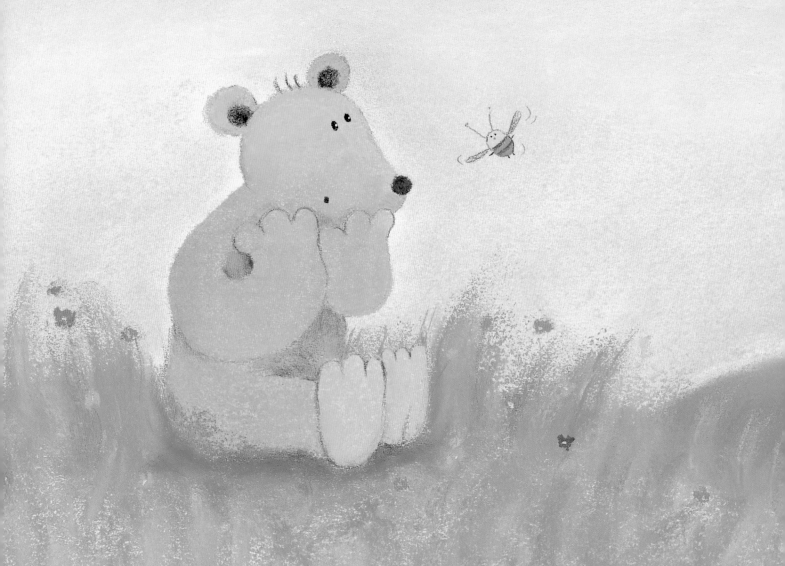

He saw all his friends coming over to him.

"Bear," said Bee, "you're very big..."

"And heavy," said Mole.

"And noisy," said Heron.

"And pesky," said Fox.

"And clumsy," said Woodpecker...

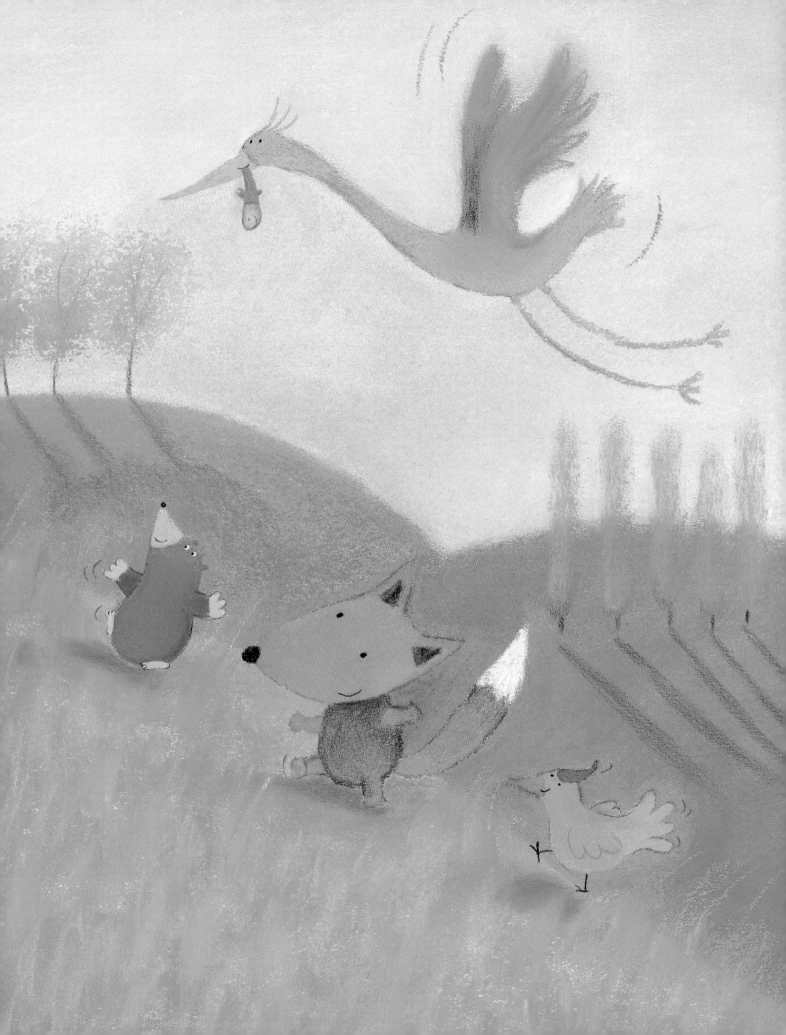

"...But you're really fun.
 Let's play!"

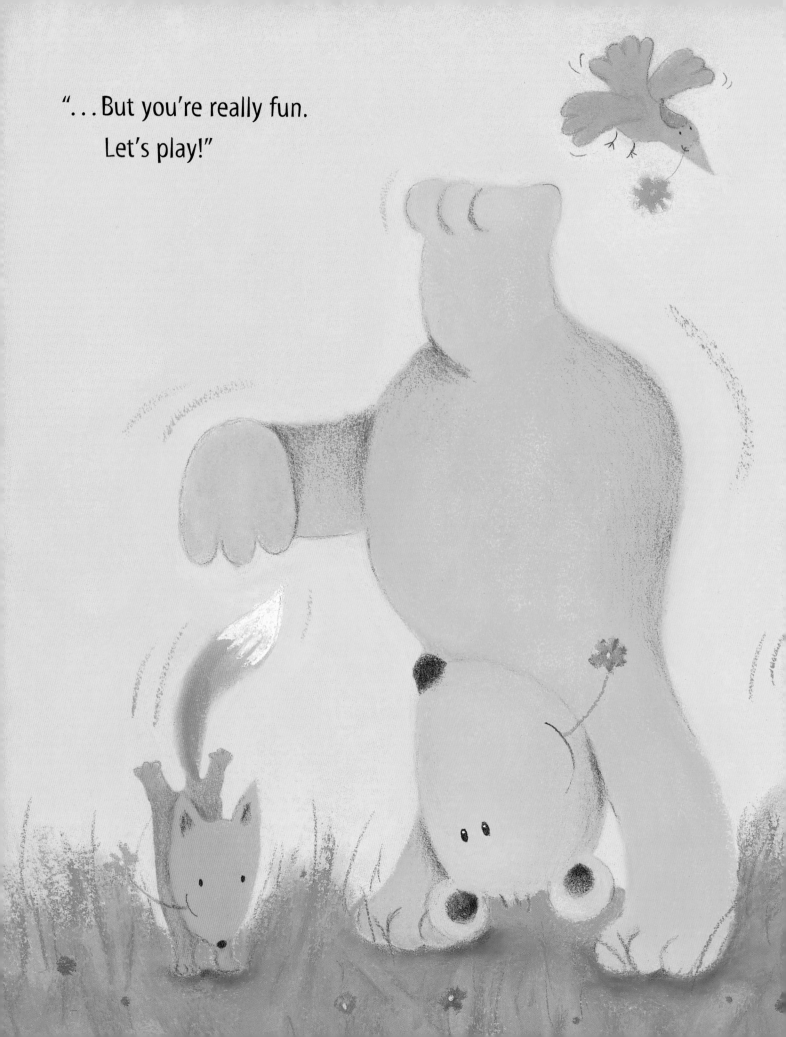

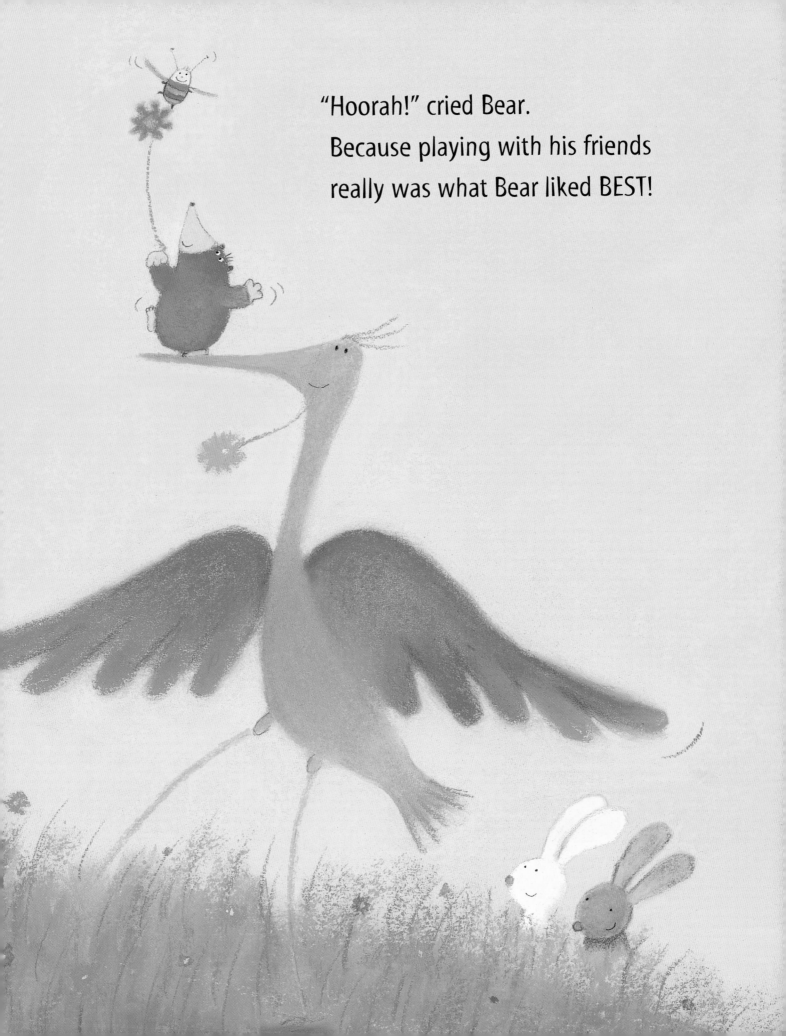

"Hoorah!" cried Bear.
Because playing with his friends
really was what Bear liked BEST!